ENCHANTED
FAIRIES
COLORING BOOK

BARBARA LANZA

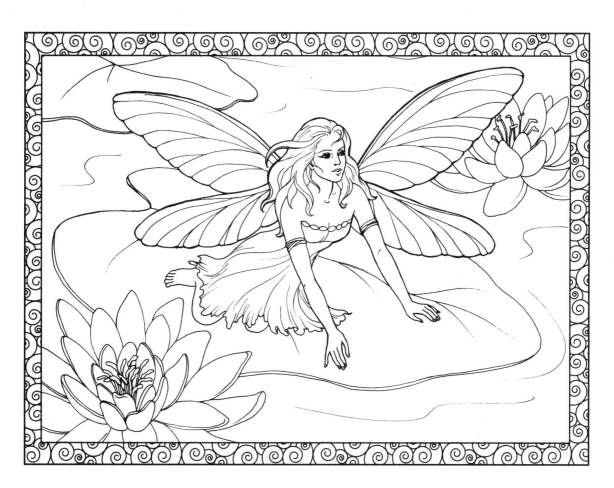

DOVER PUBLICATIONS, INC.
MINEOLA, NEW YORK

"Enchanted" is the word for this delightful array of graceful fairyland beauties. You'll meet a variety of fairies dressed in leafy creations and flowing gowns, set among scenes that include flower petals, garden plants, a crescent moon, and even a teacup! The unbacked plates allow you to use any coloring media you like, and the perforated pages make displaying your finished work easy.

Bibliographical Note
Enchanted Fairies Coloring Book is a new work,
first published by Dover Publications, Inc., in 2015.

International Standard Book Number
ISBN-13: 978-0-486-79918-6
ISBN-10: 0-486-79918-2

Manufactured in the United States by RR Donnelley
79918206 2016
www.doverpublications.com

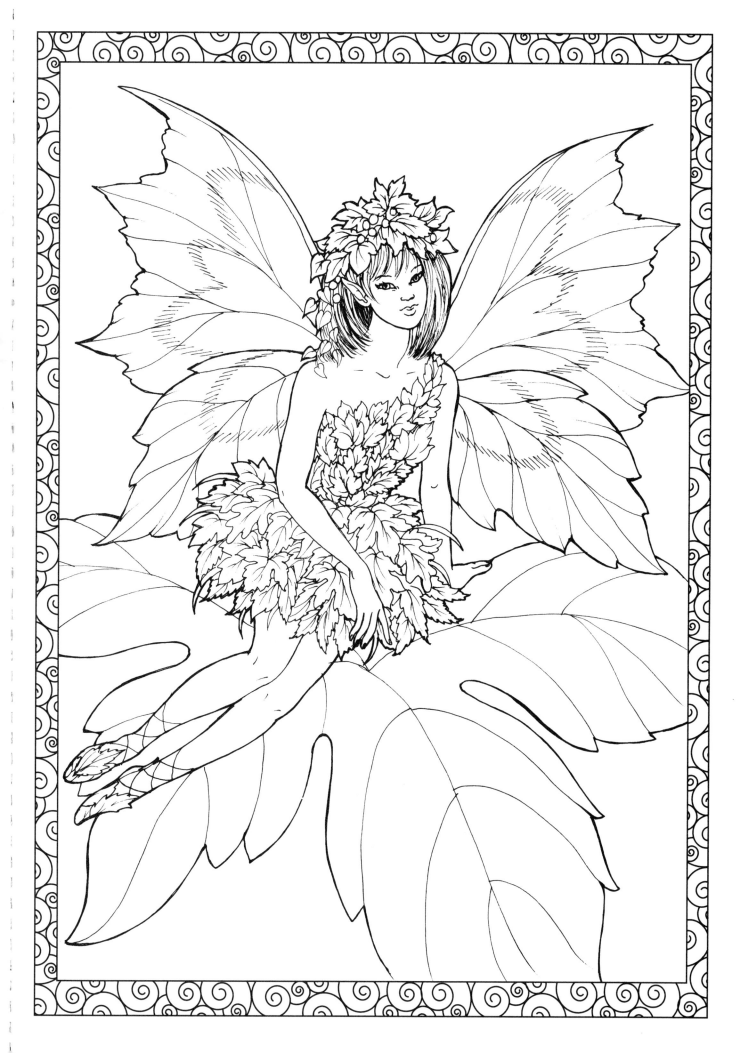

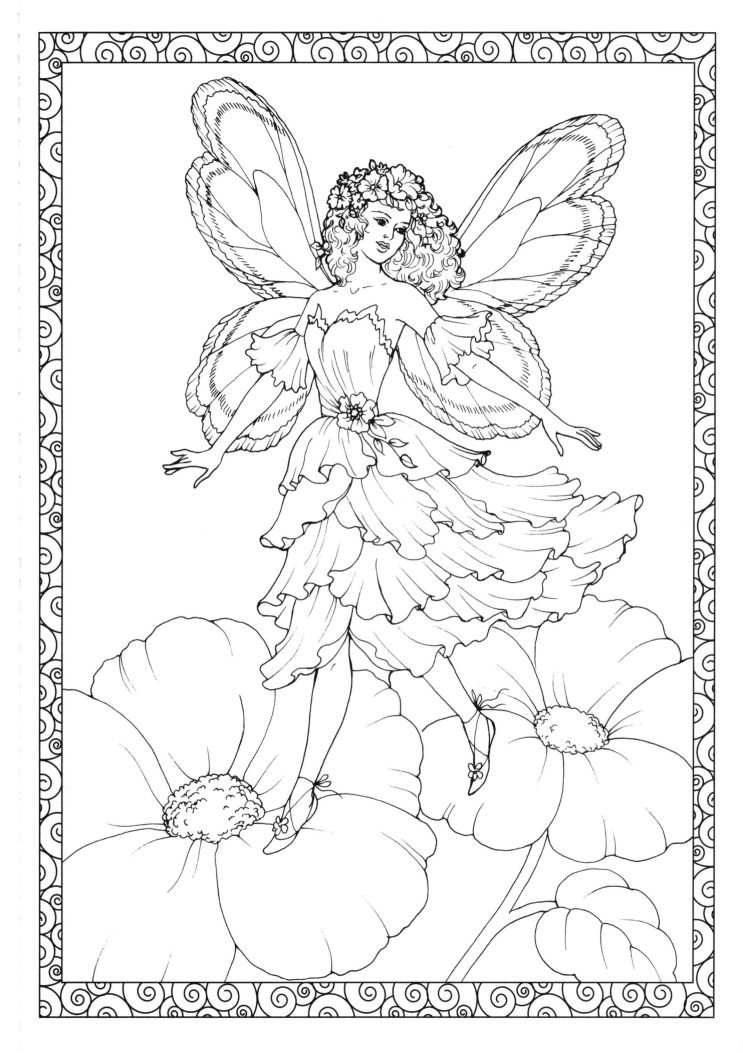

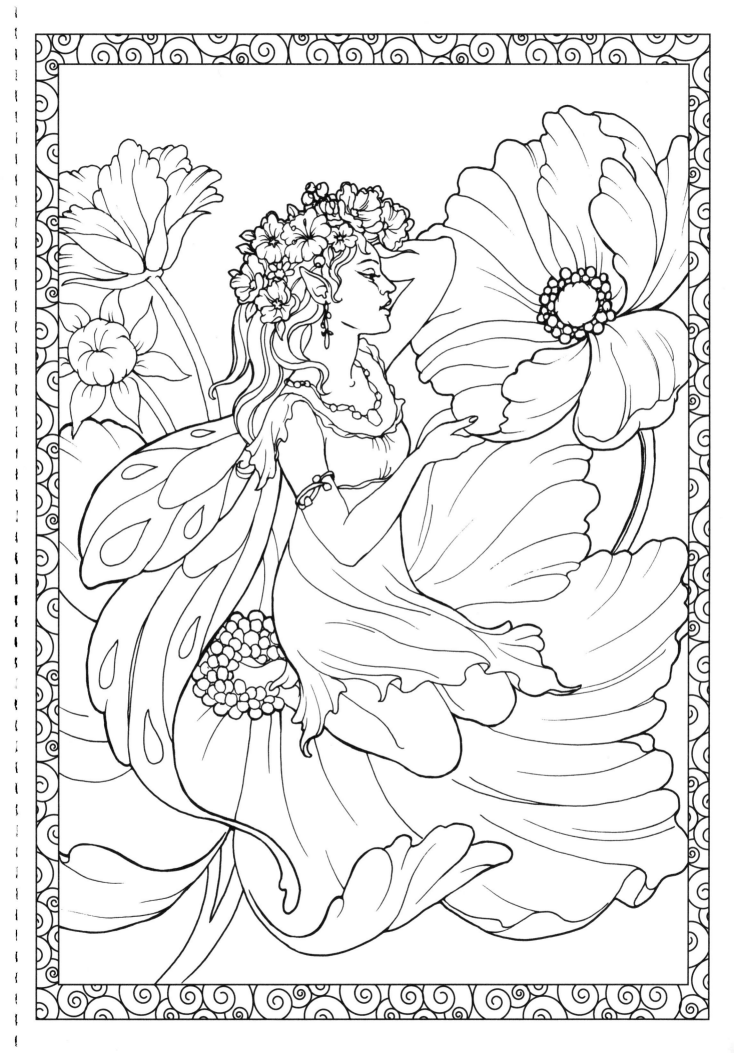

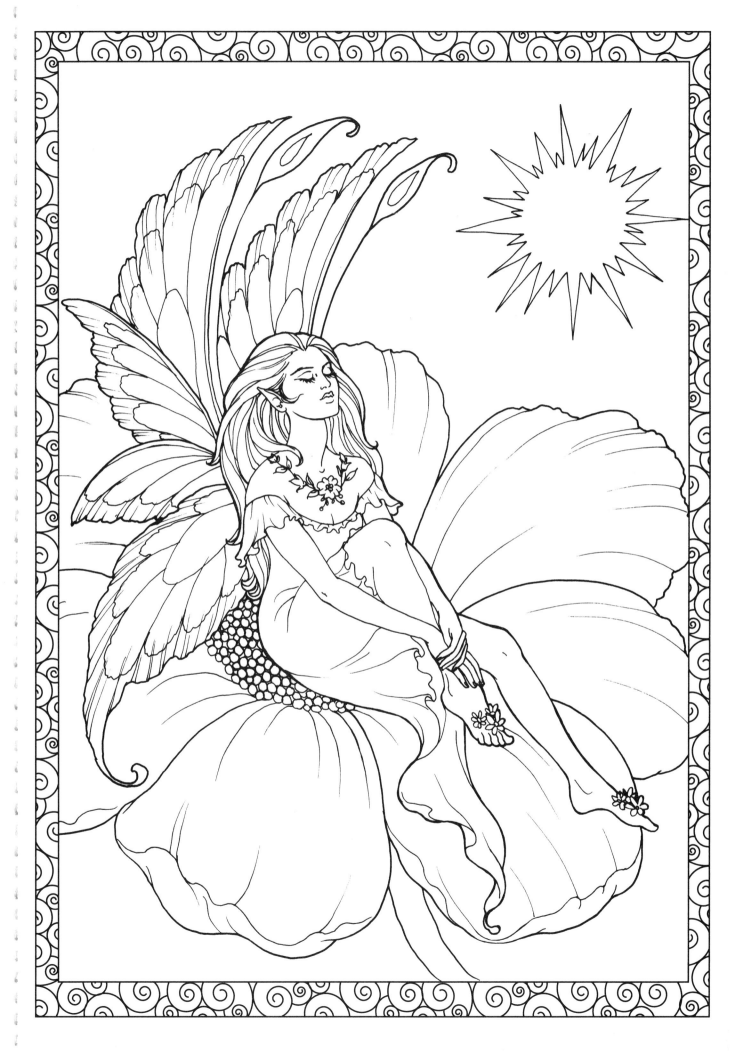

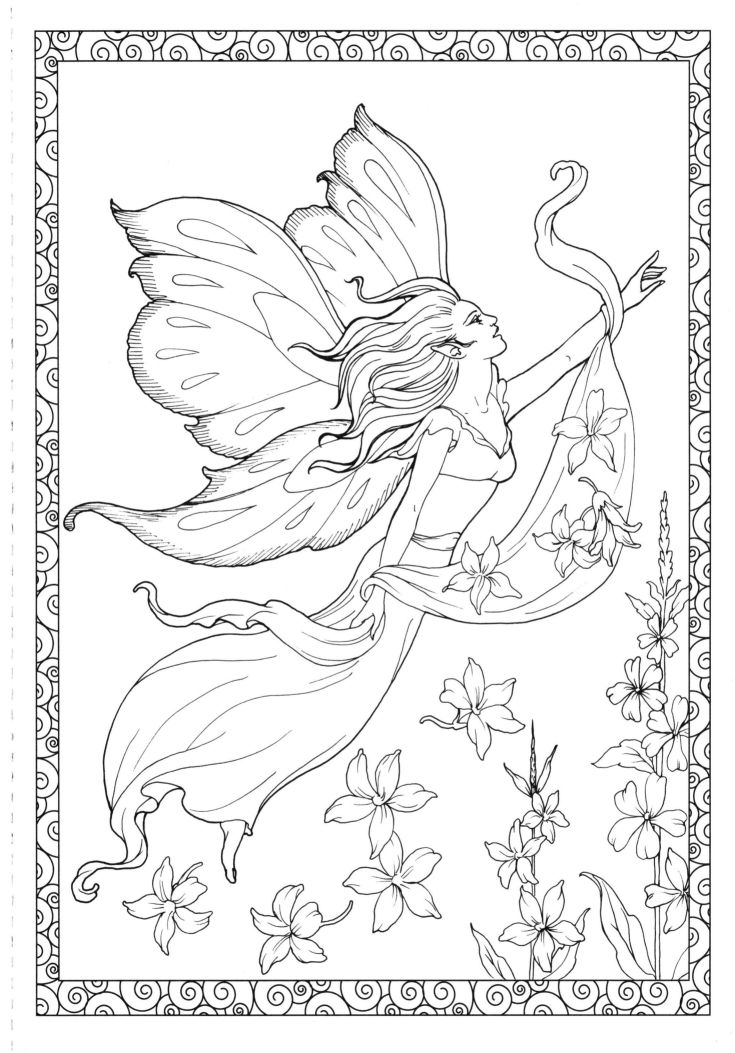

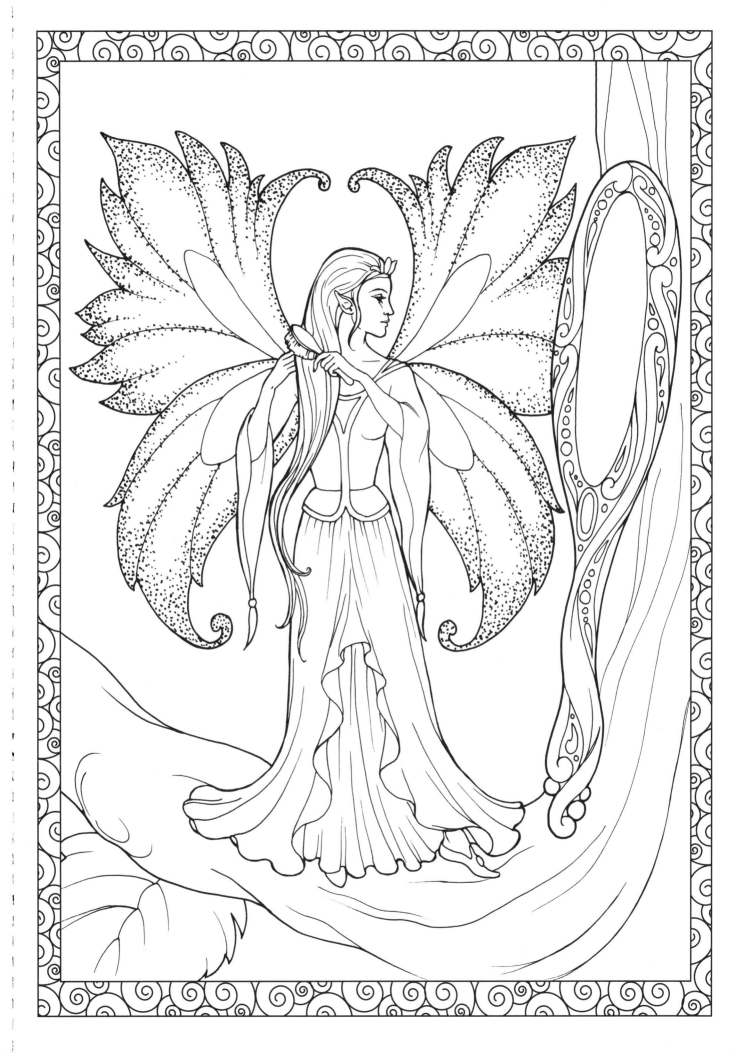

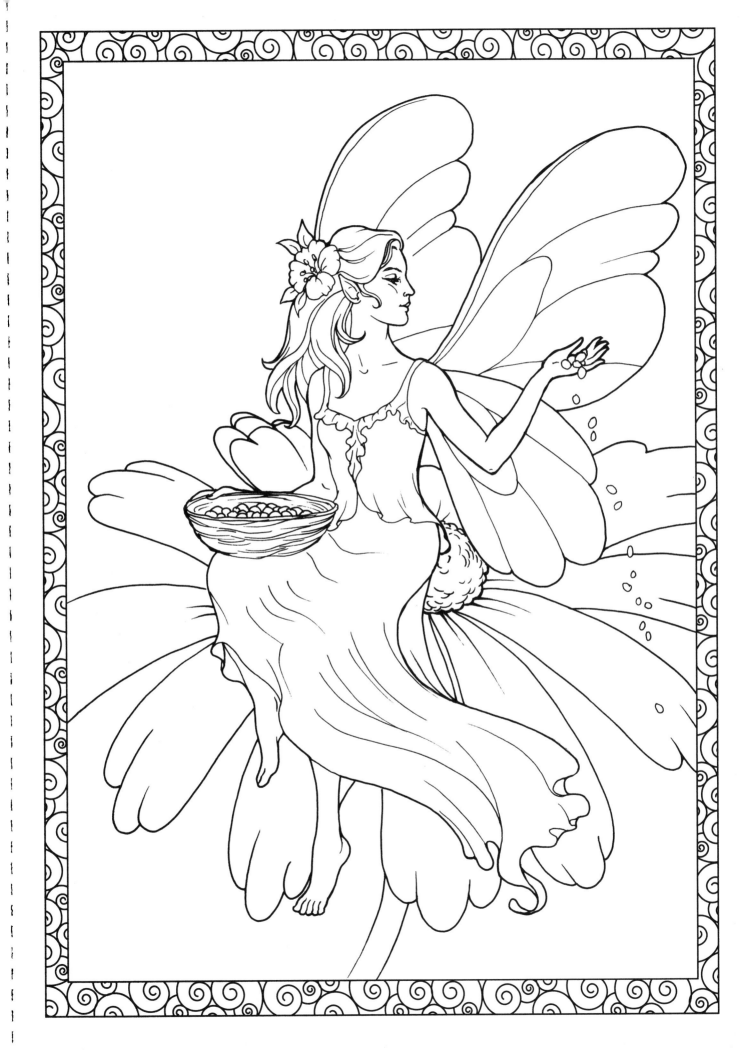

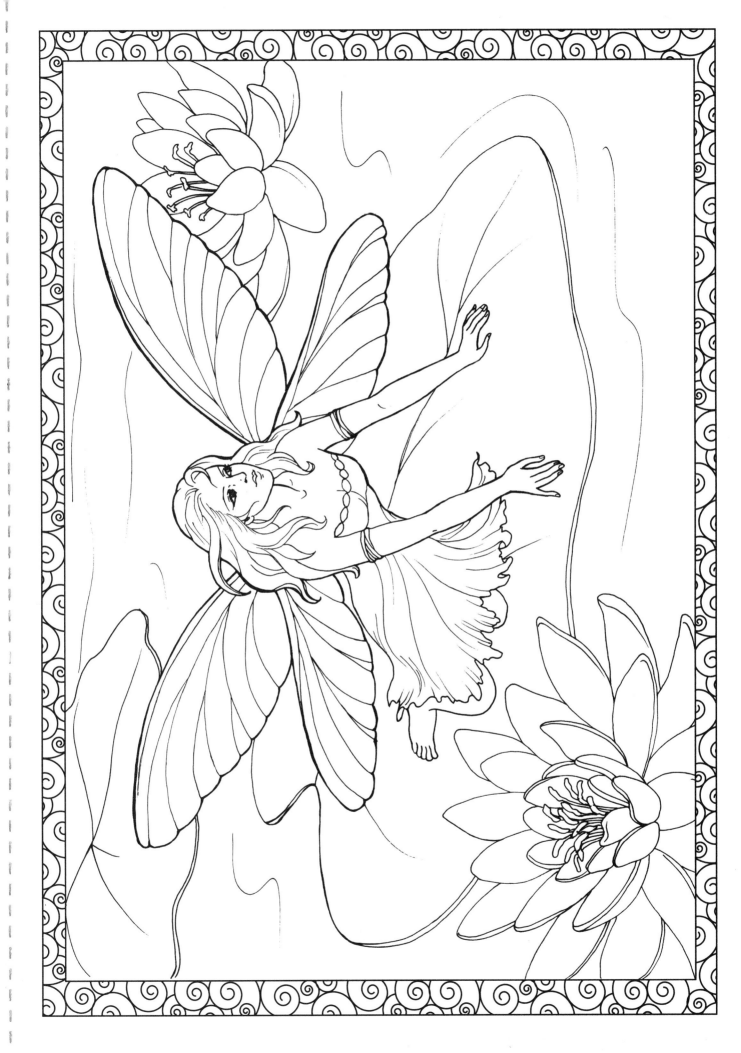

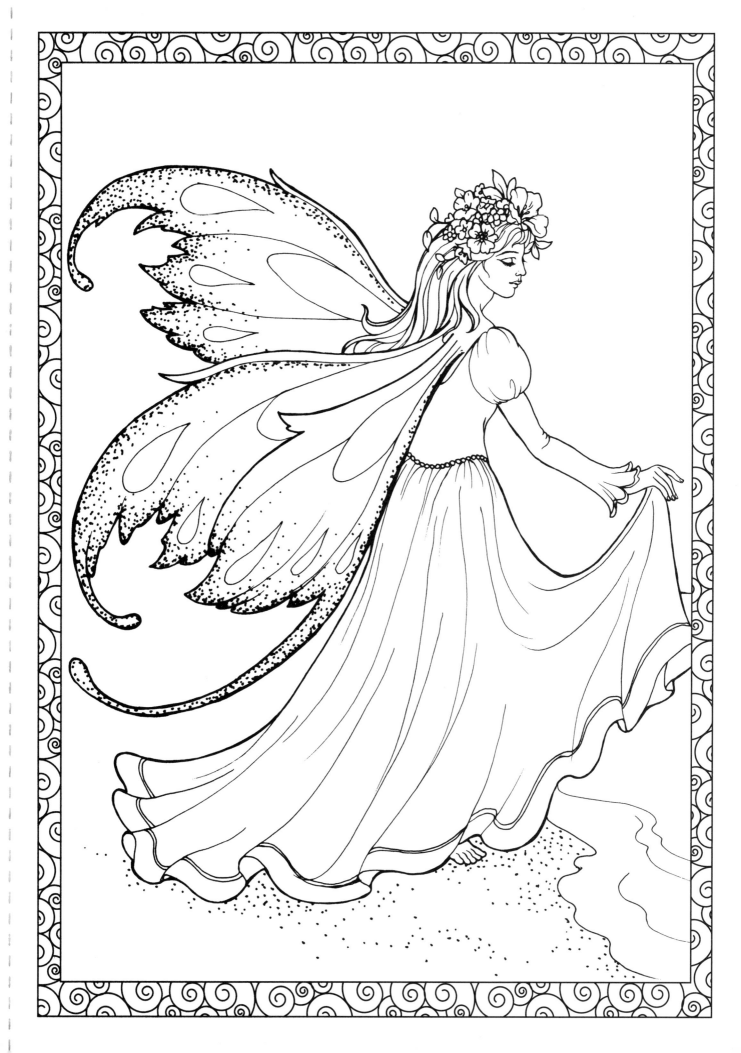

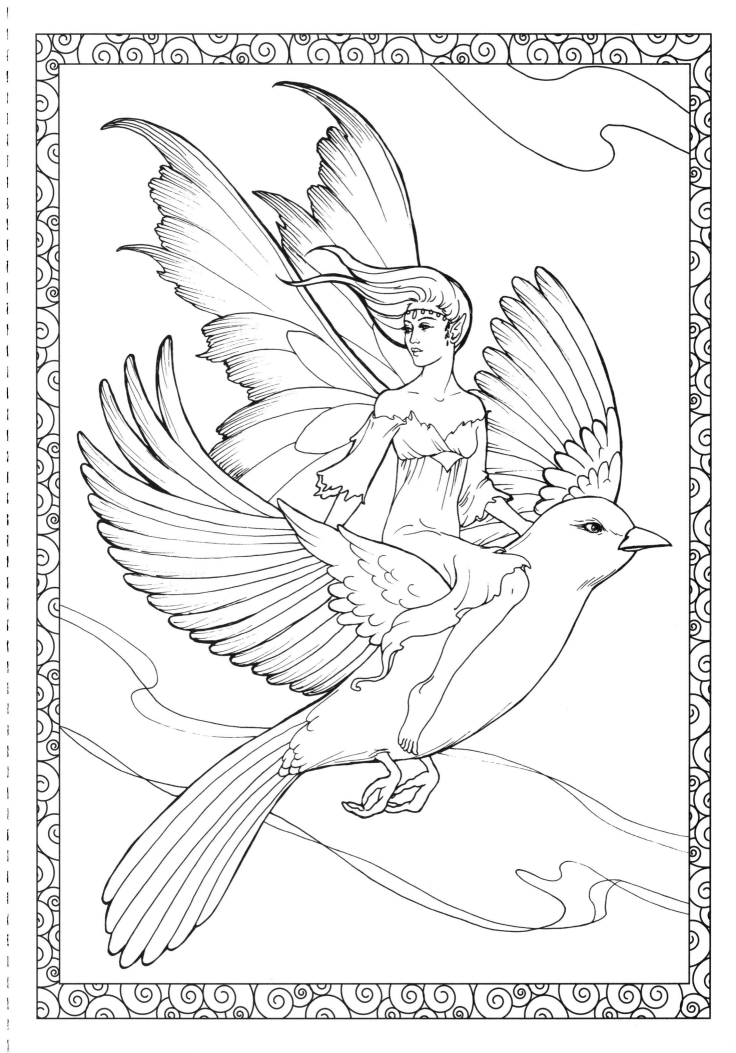

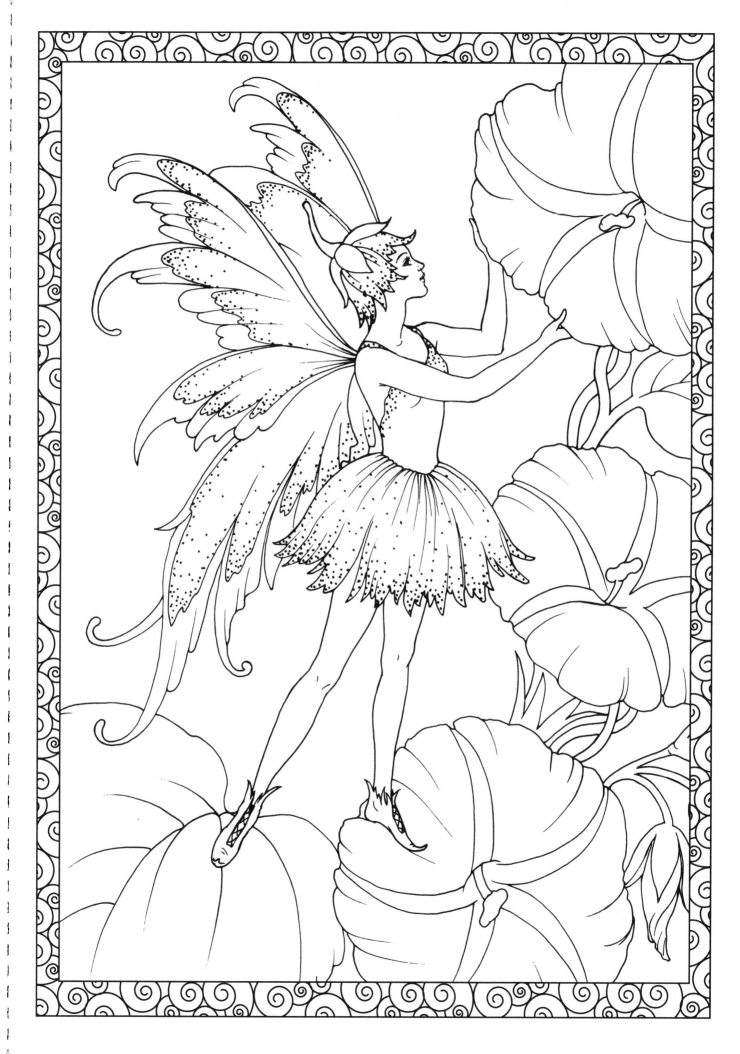

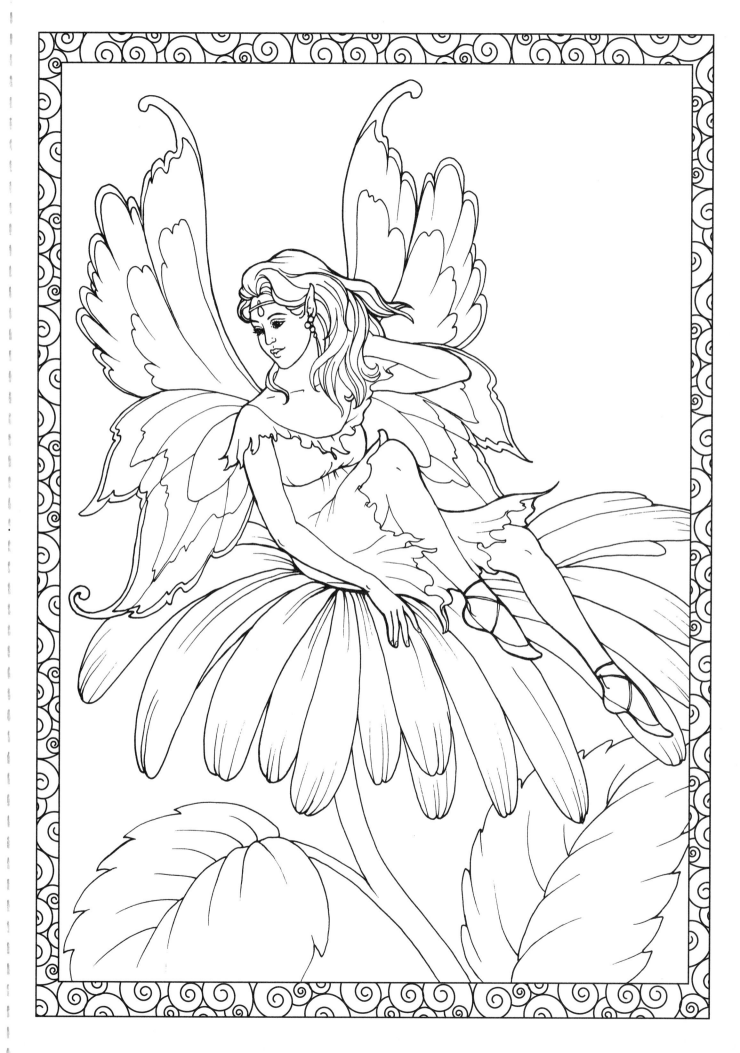

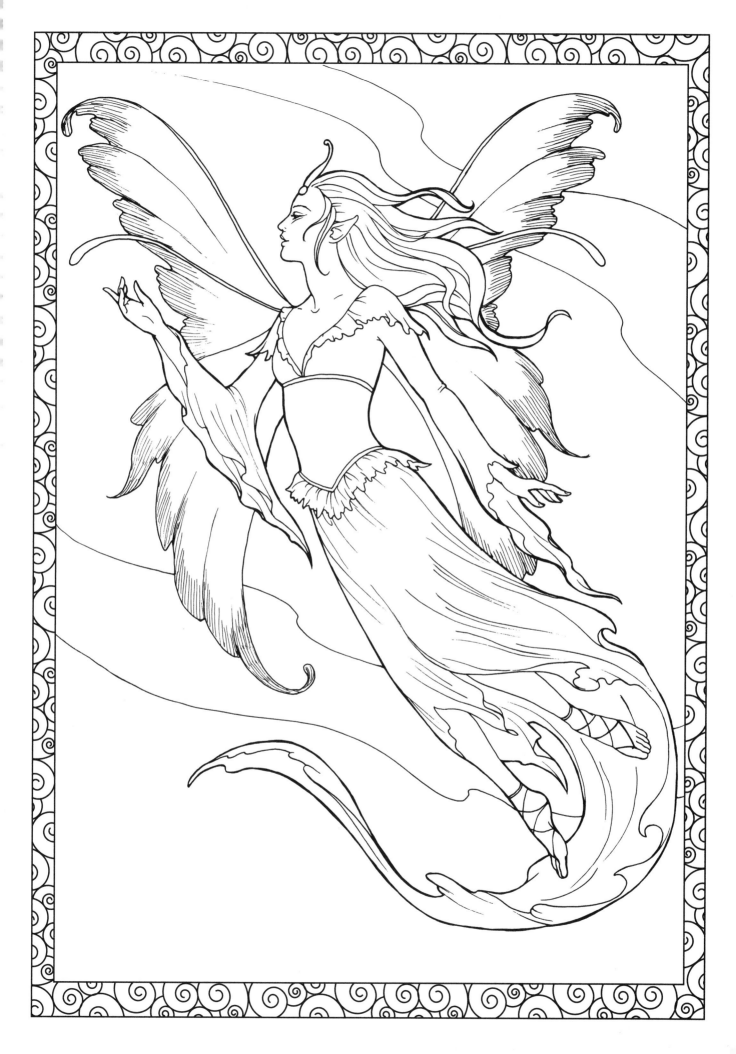

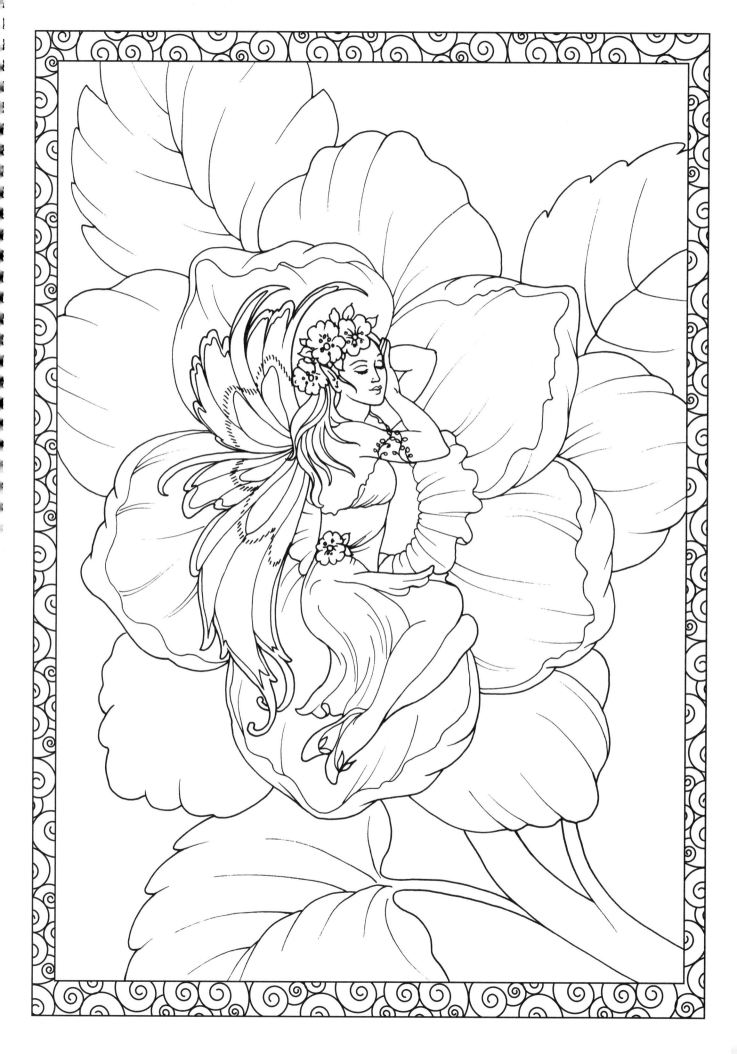

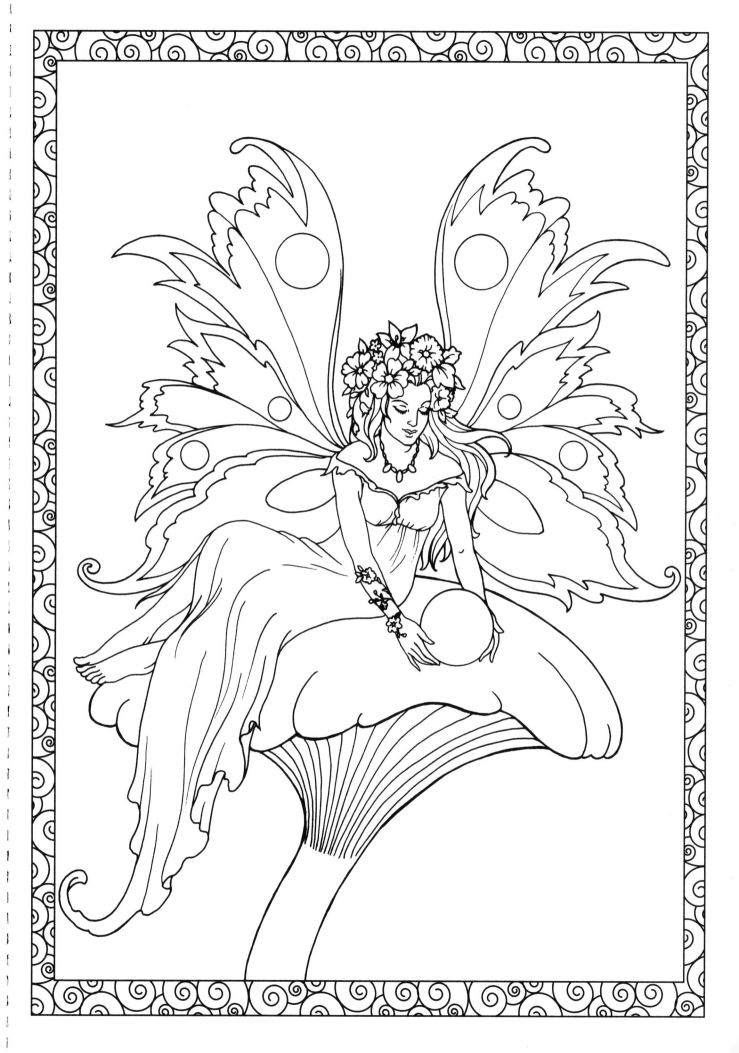

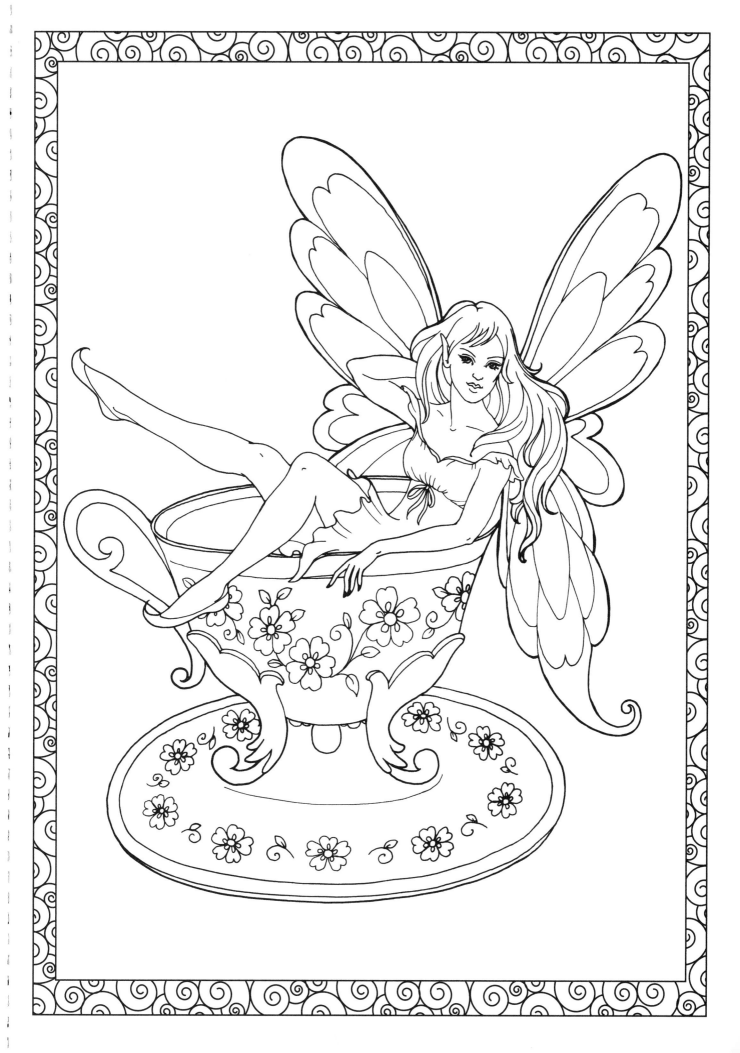

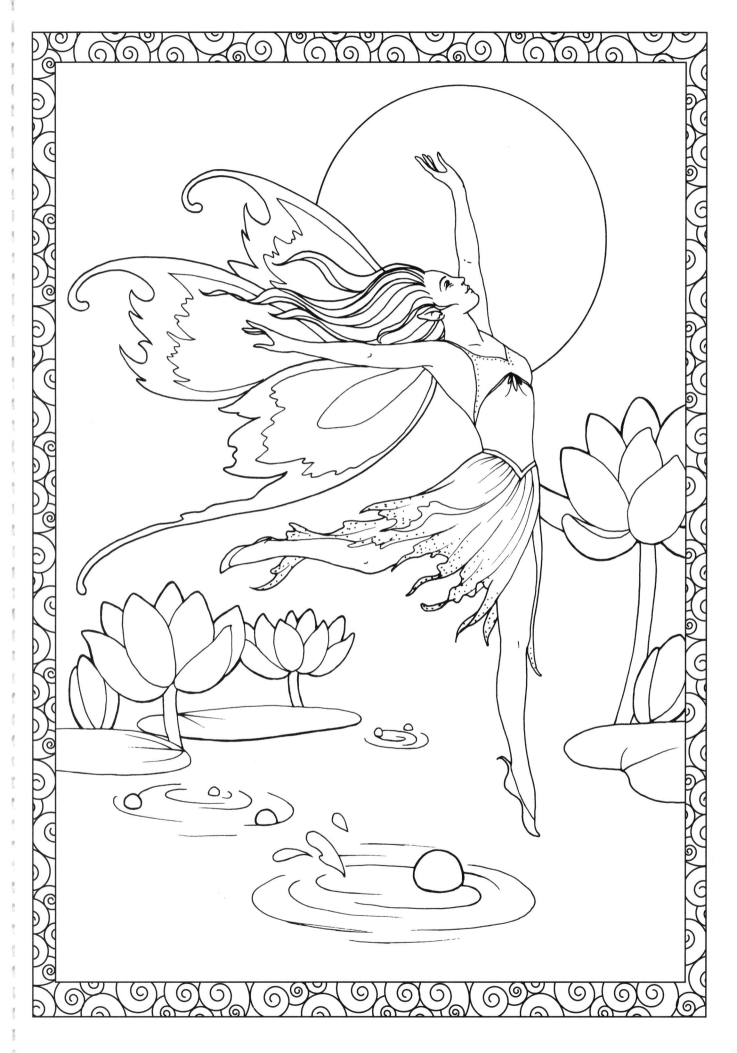

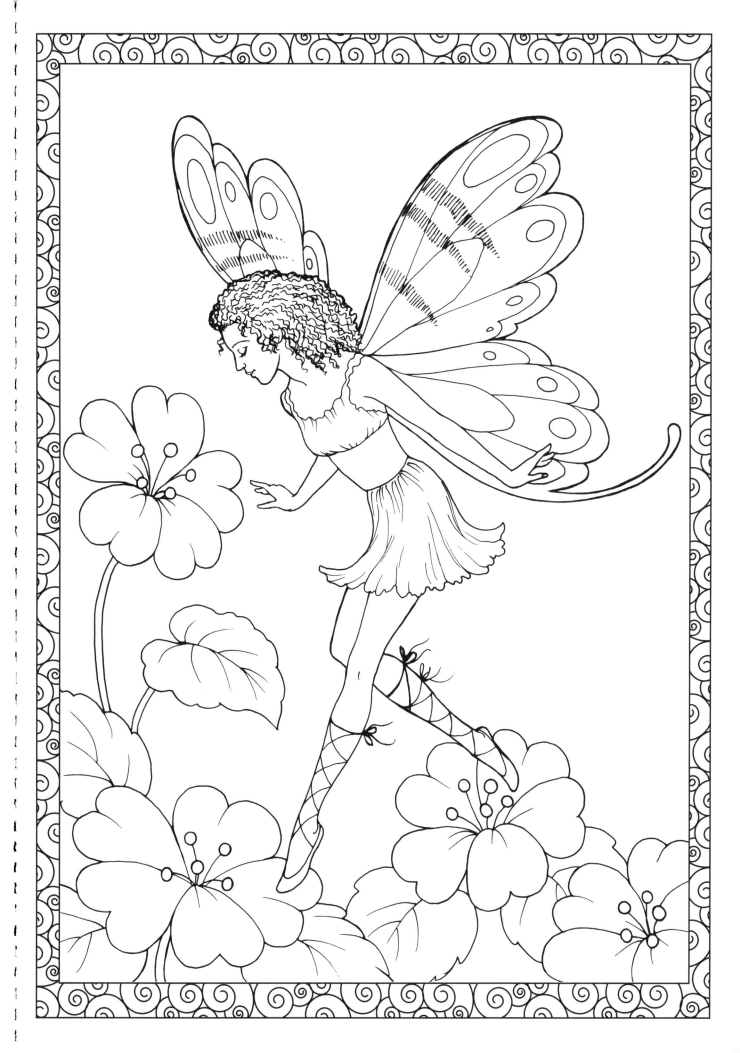

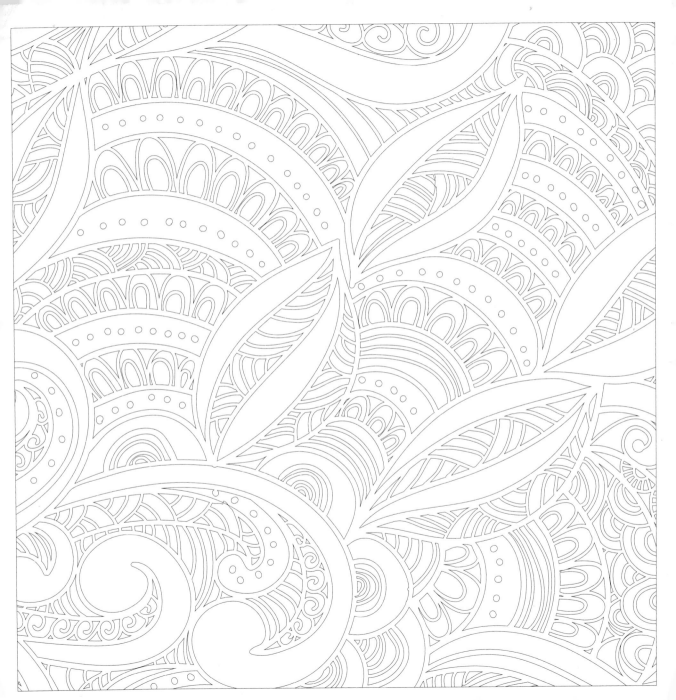

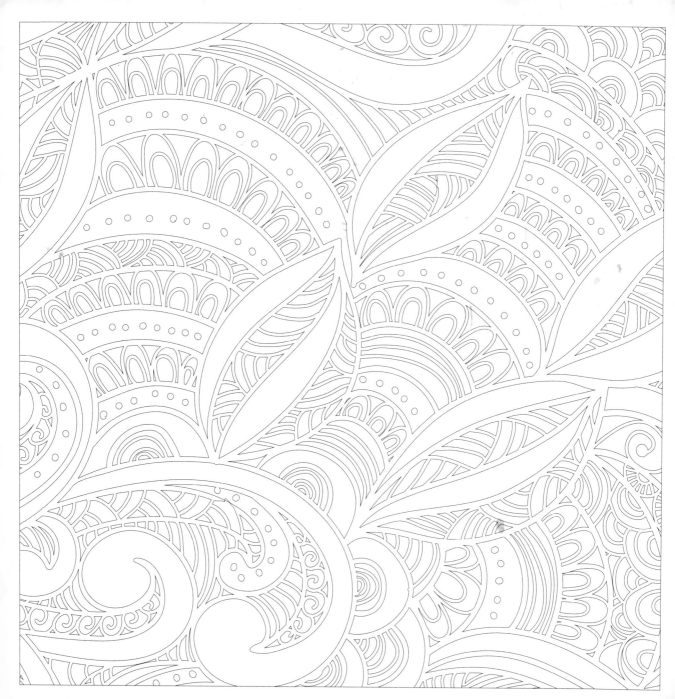

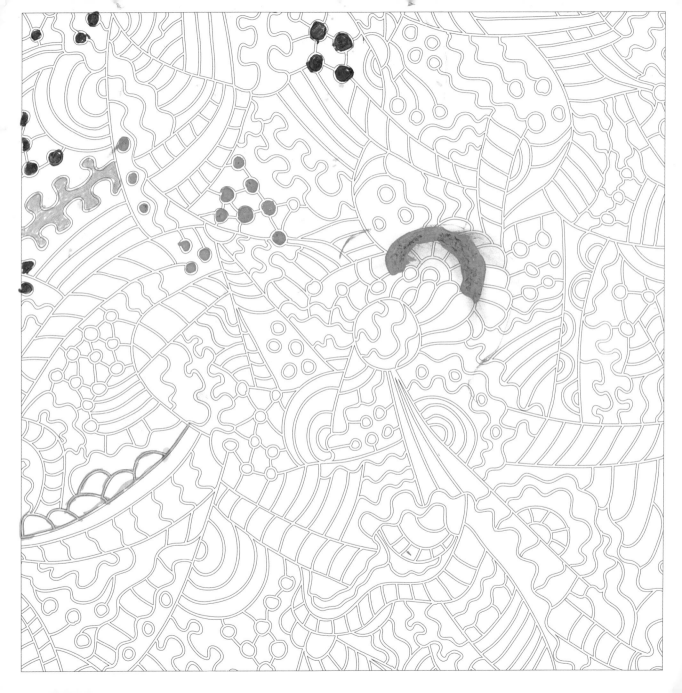

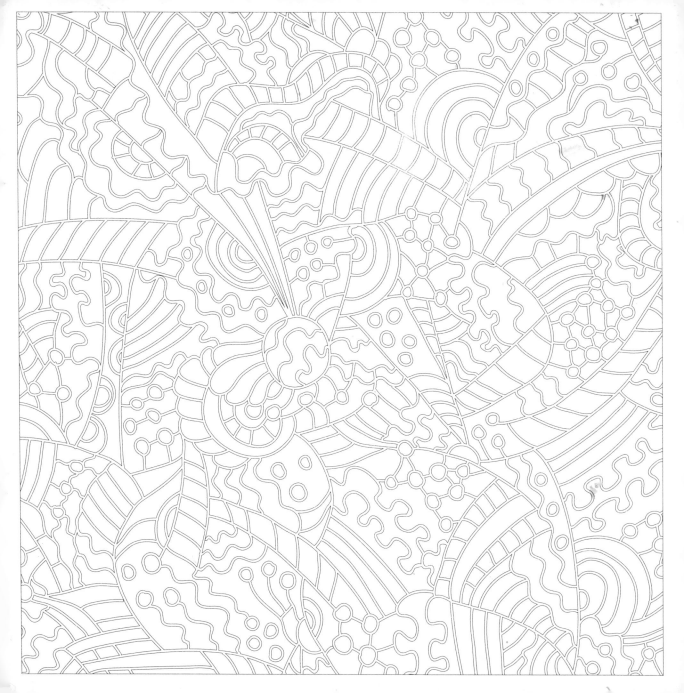

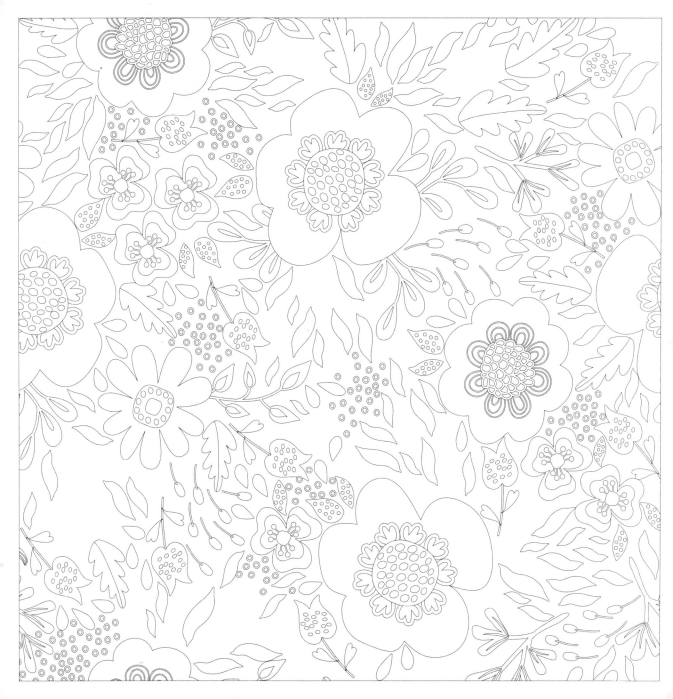

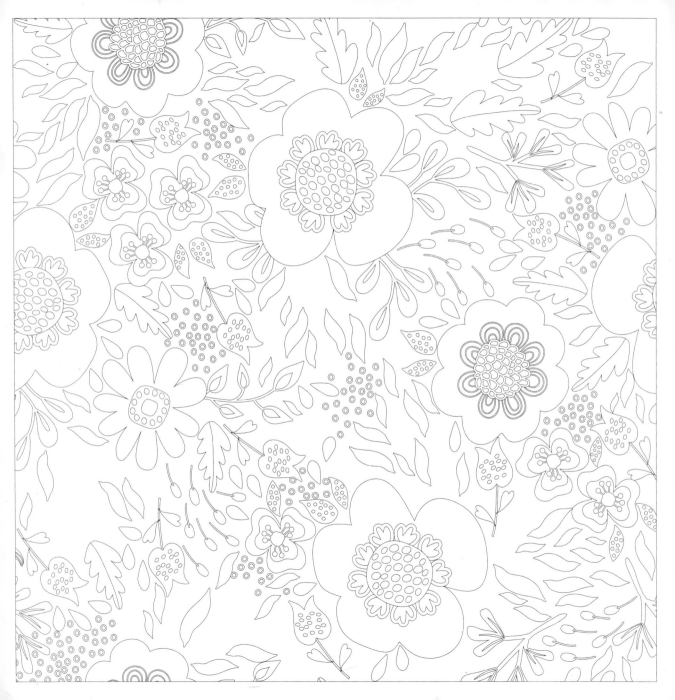

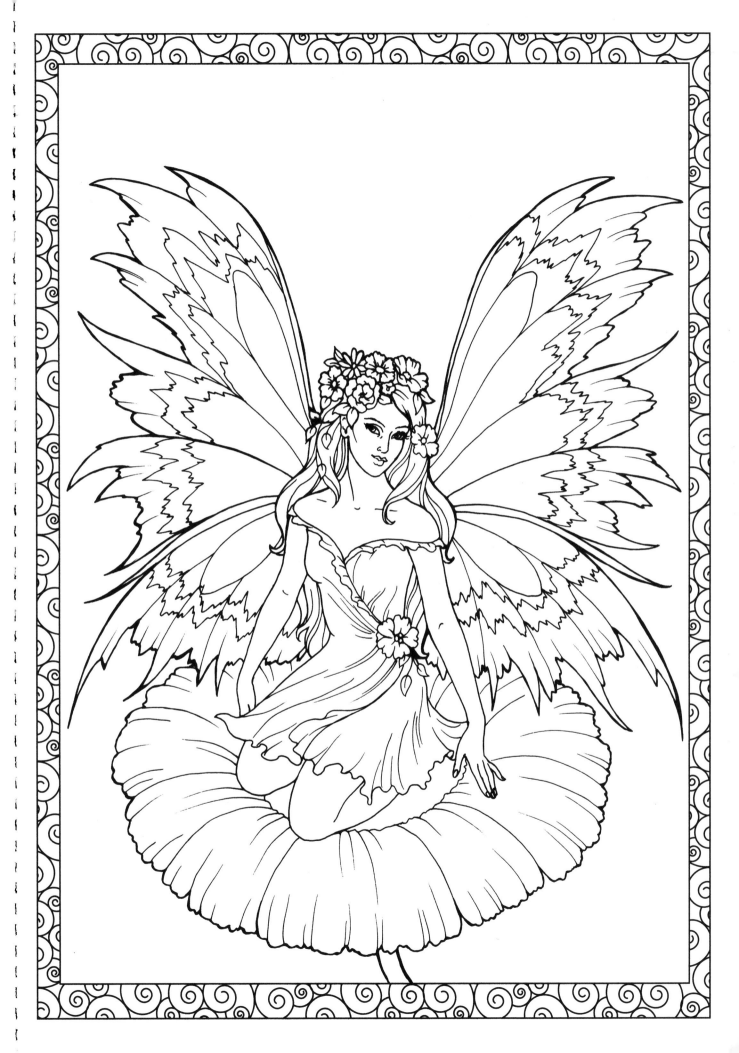

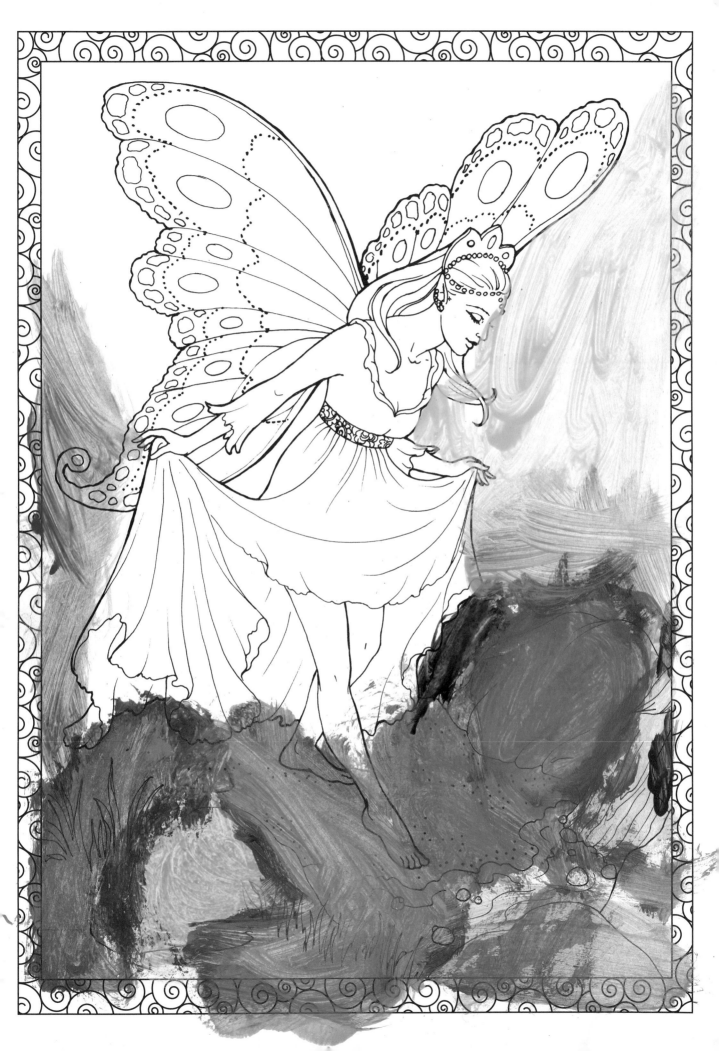

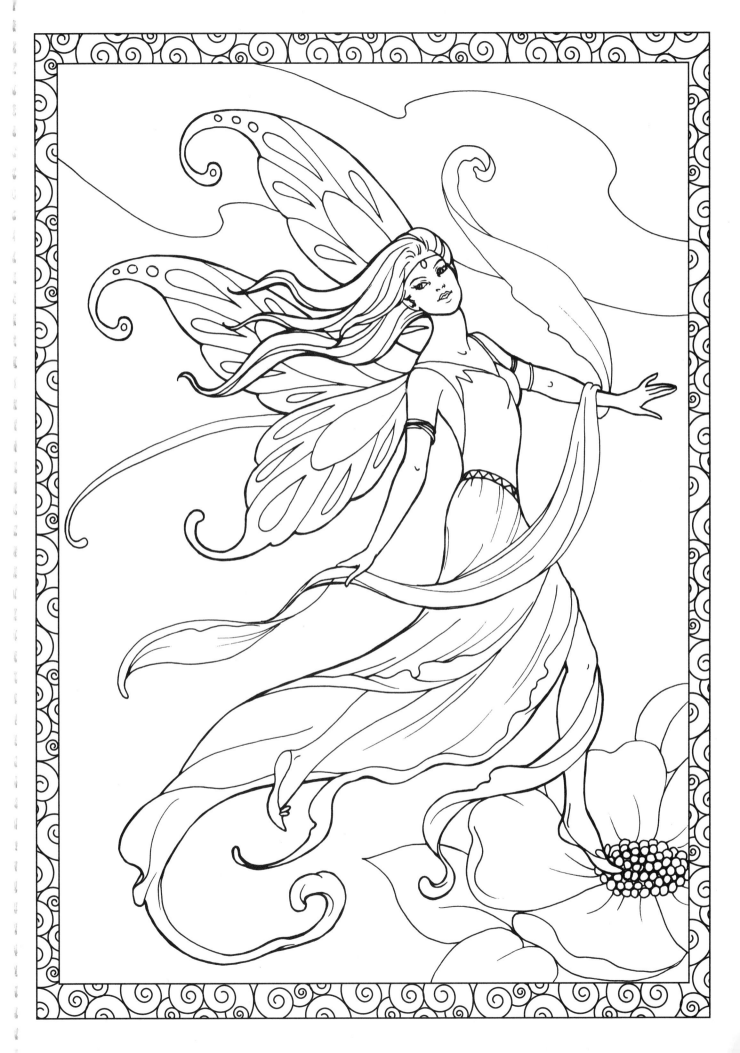

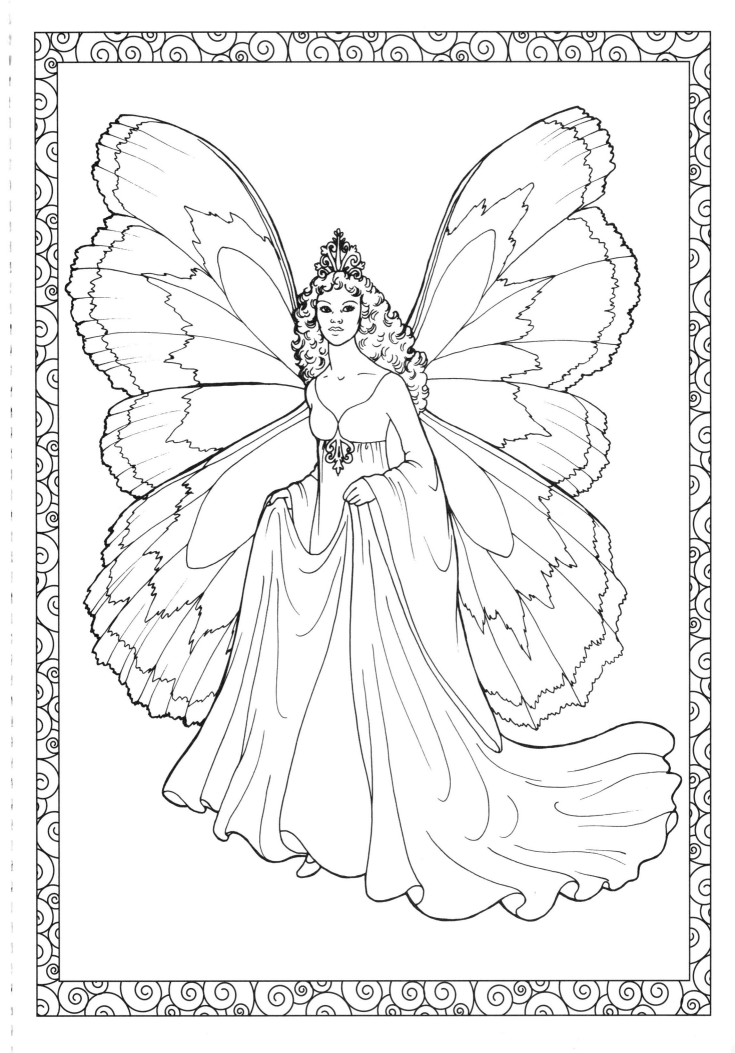

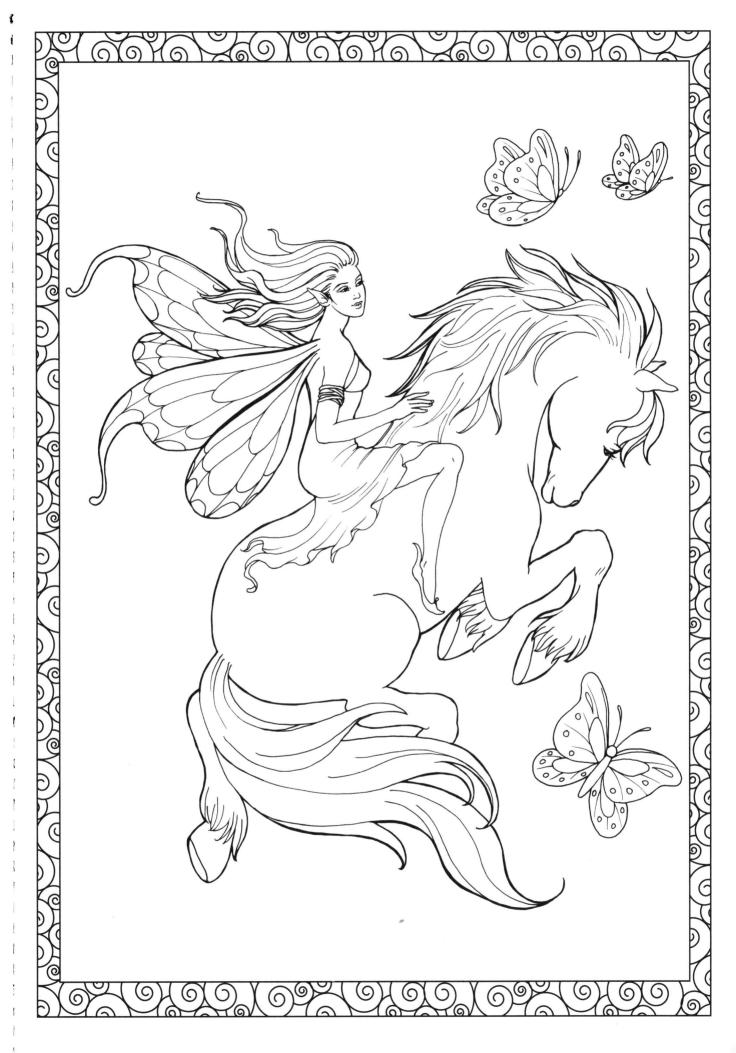

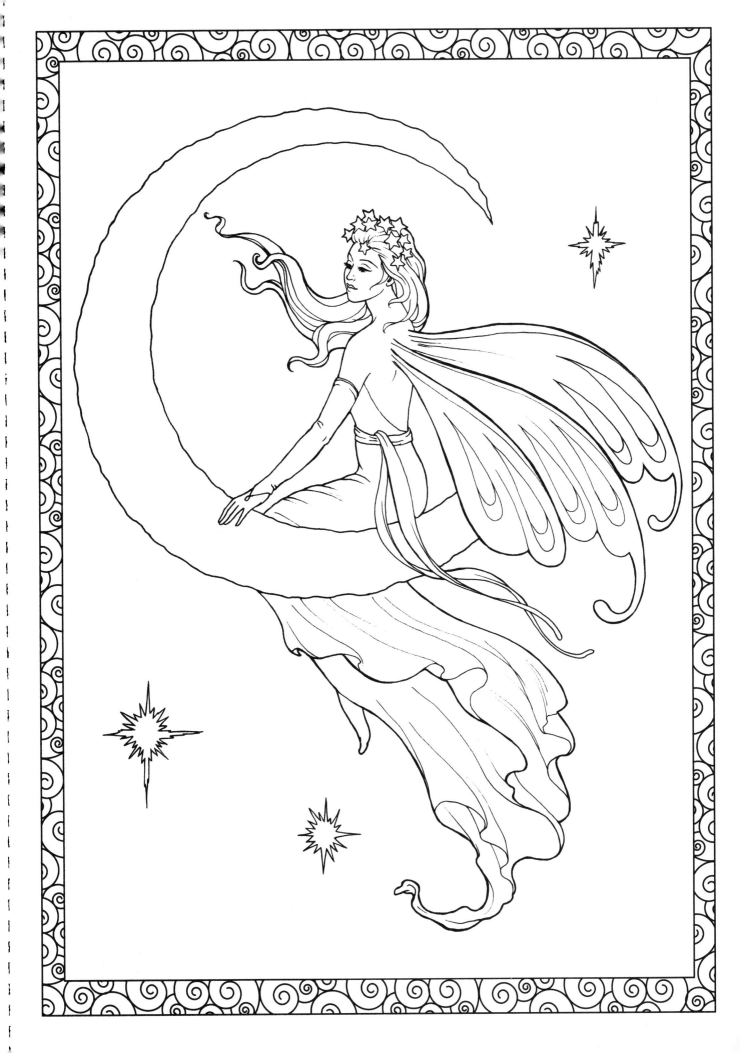

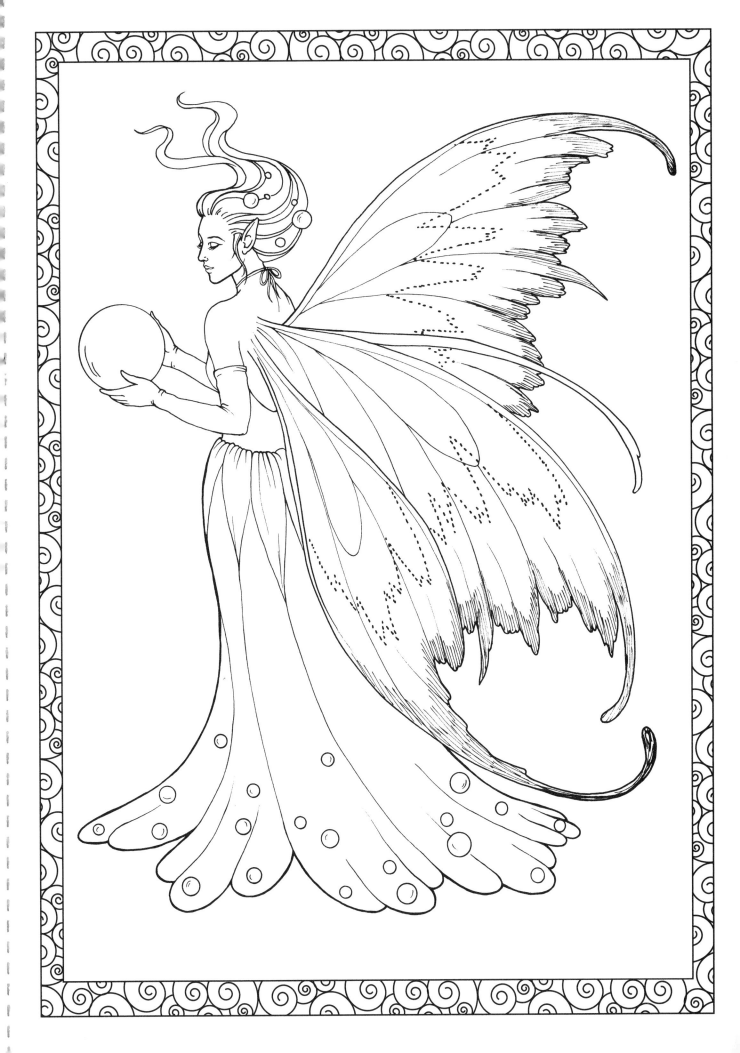

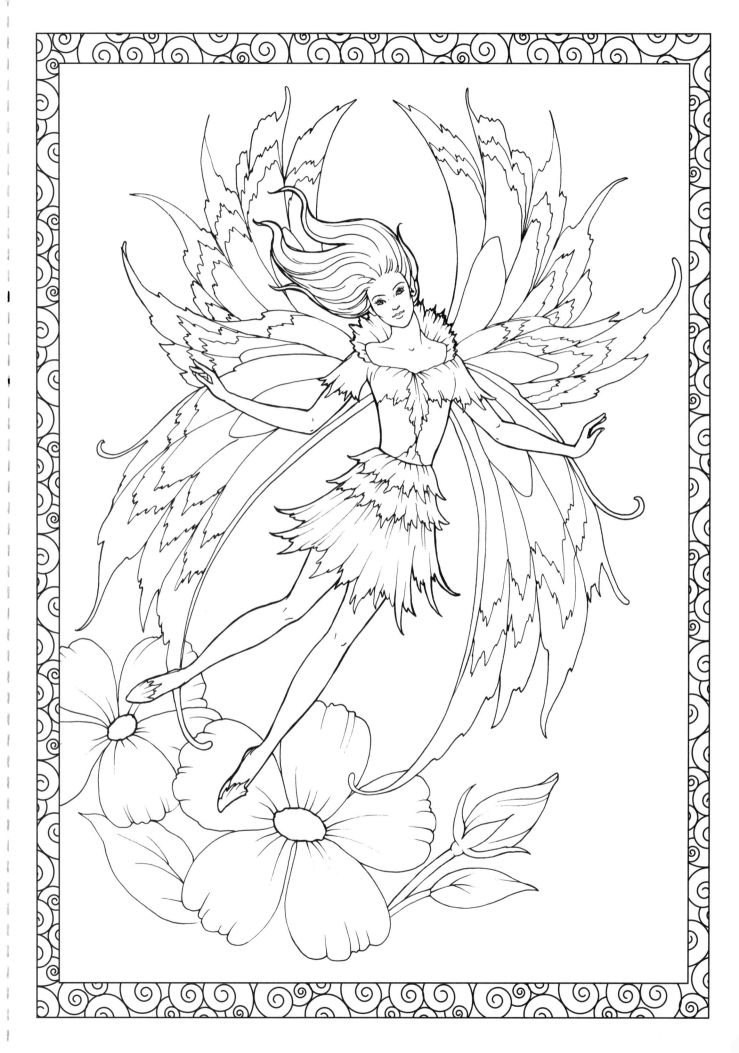

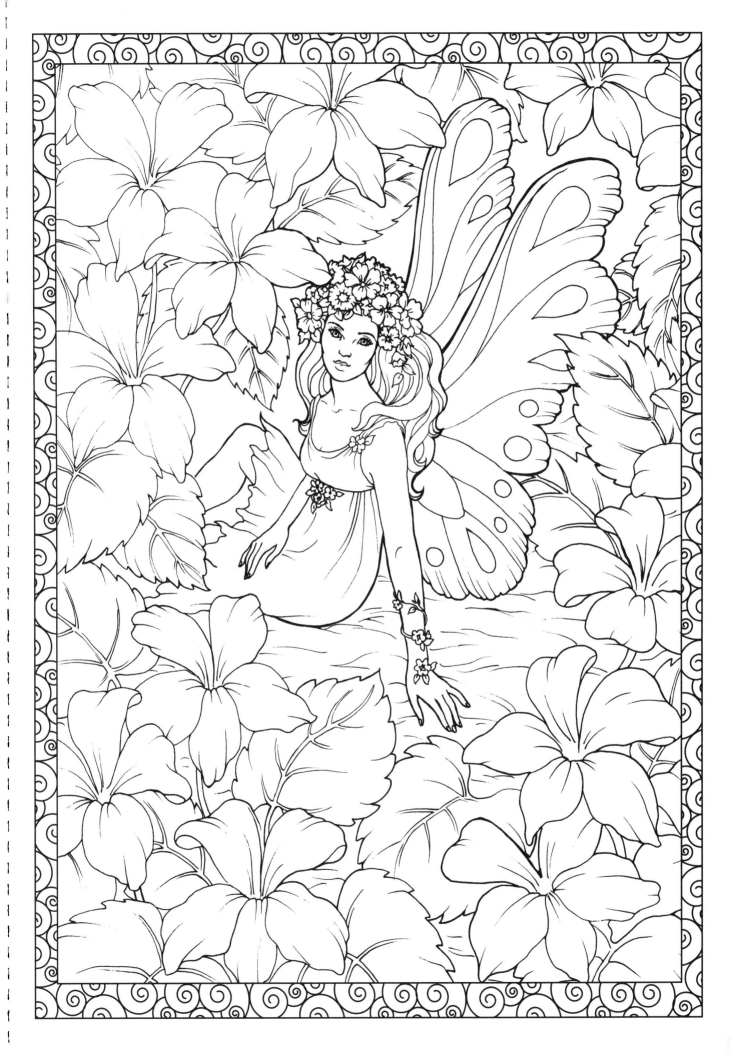

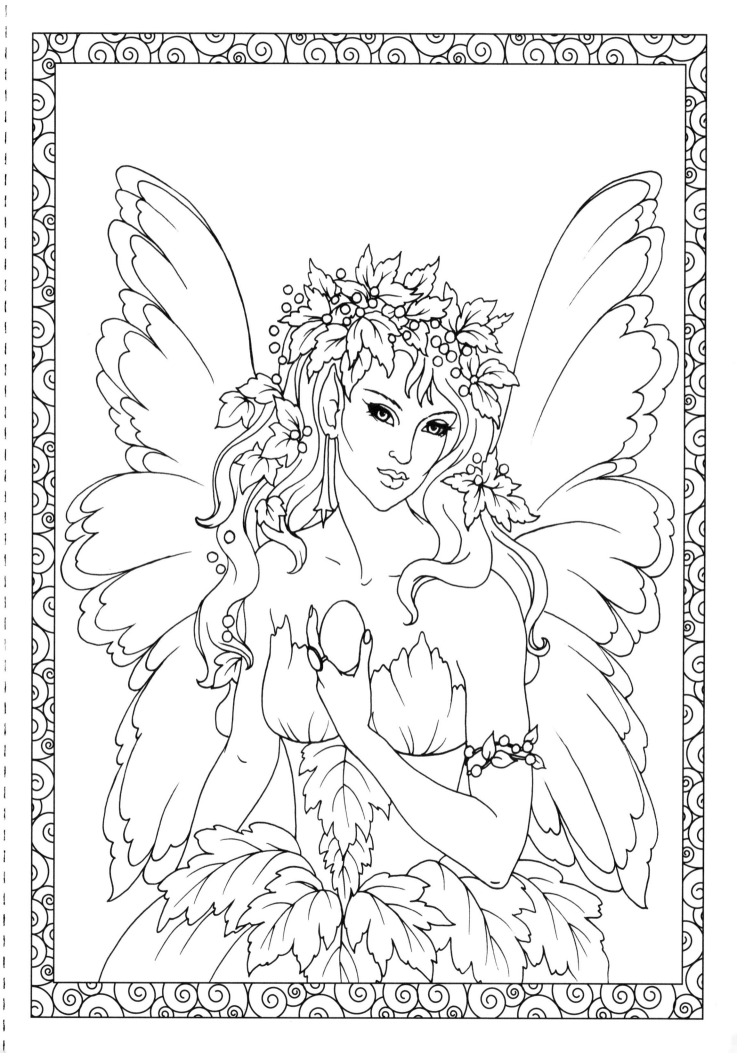

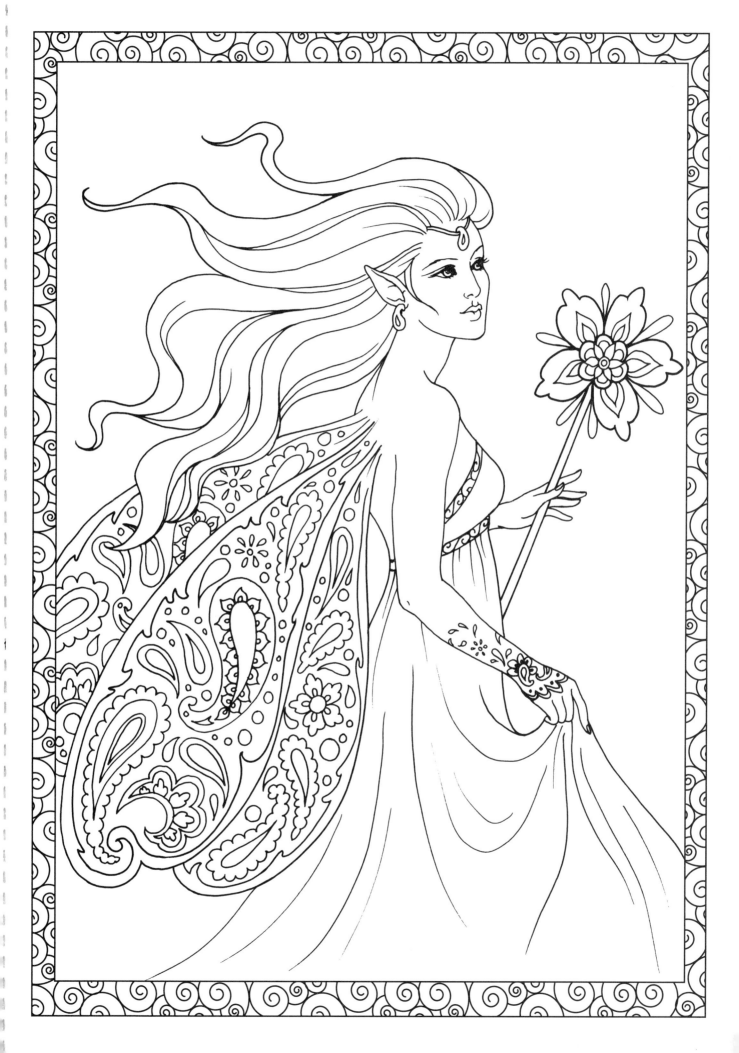

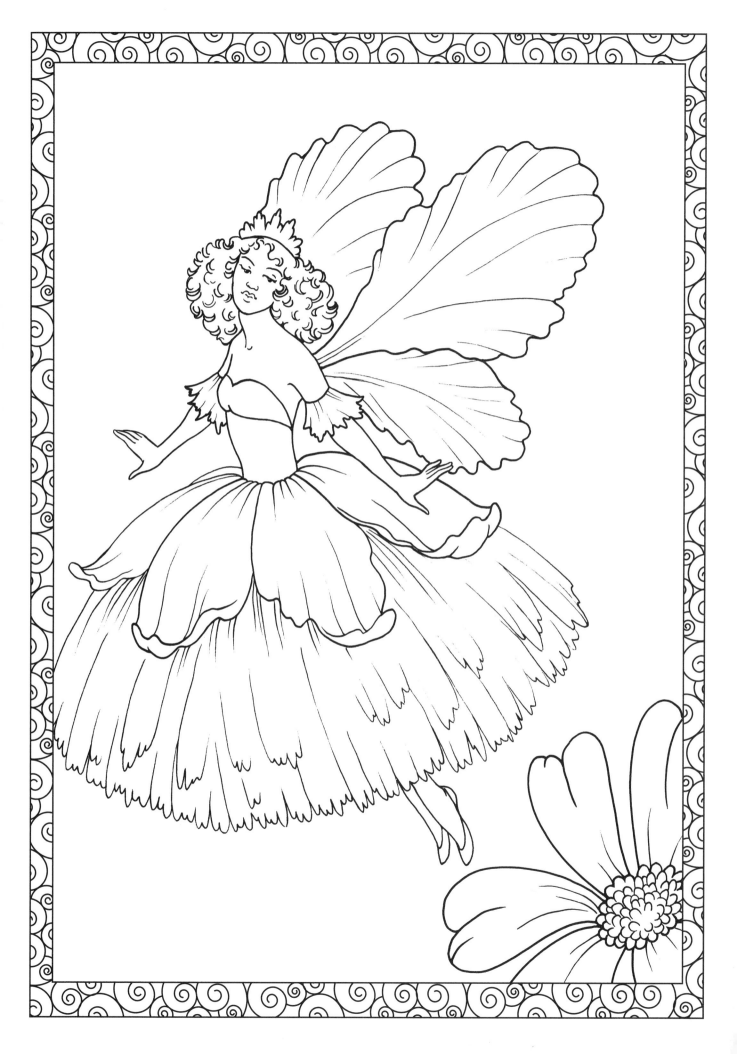

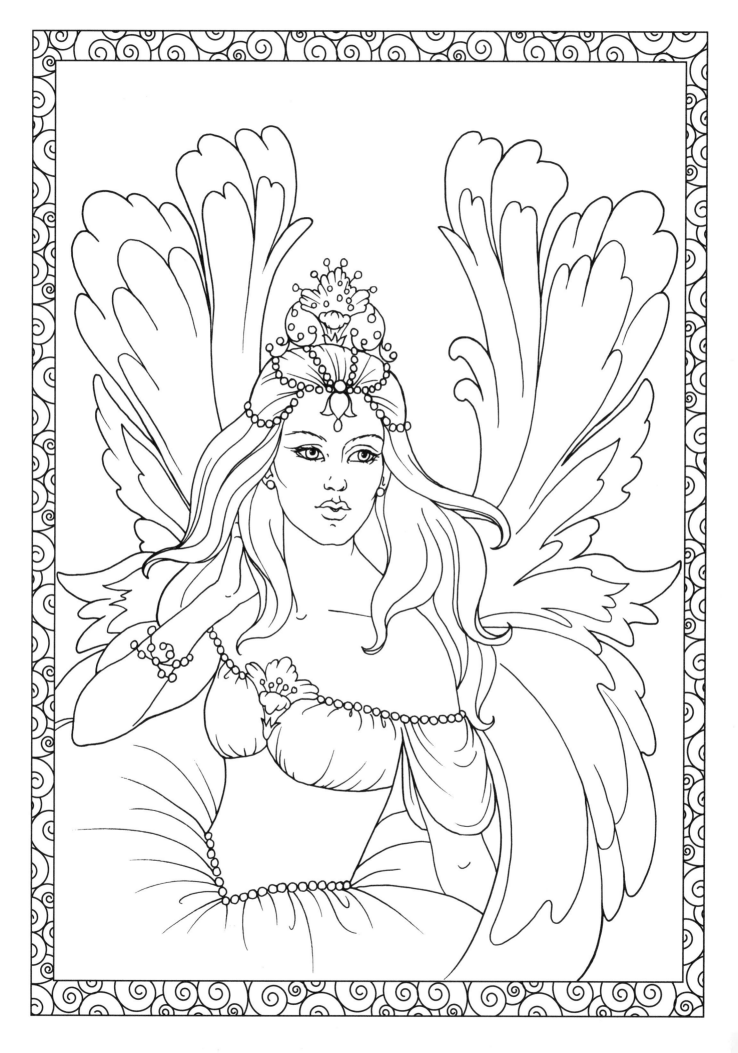